Henri Rousseau's Jungle Book

Prestel

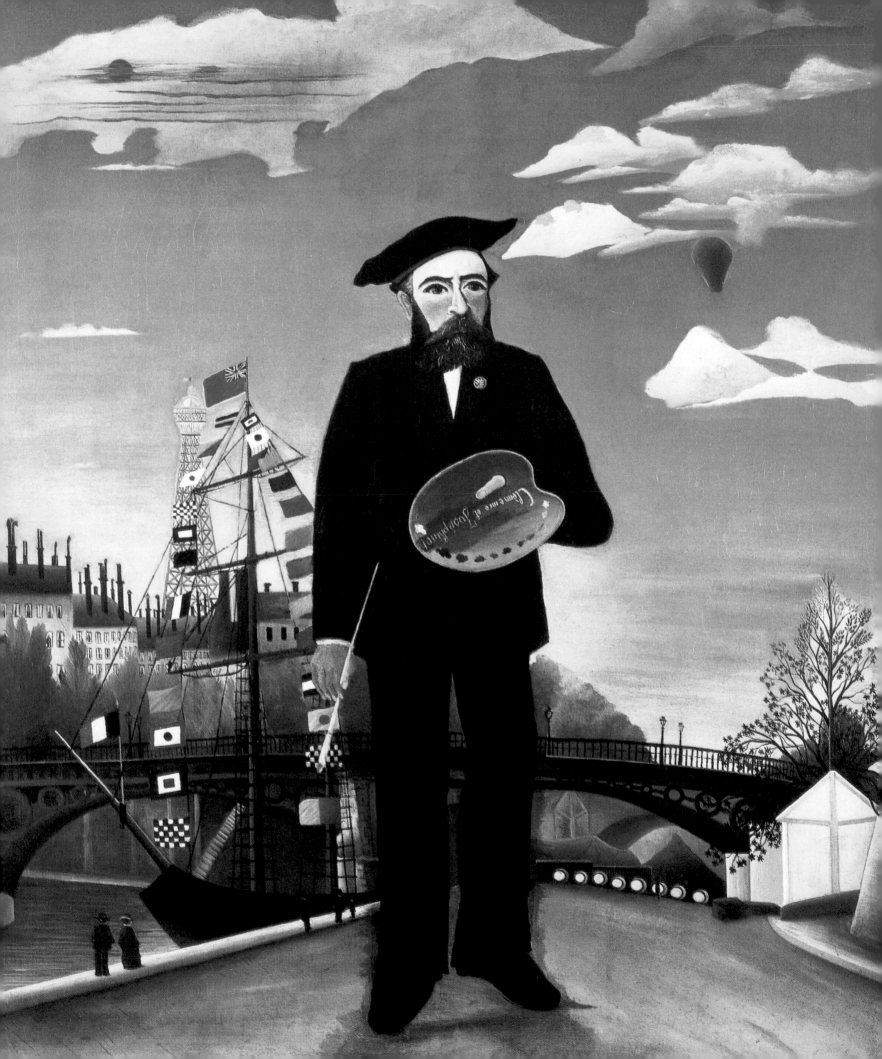

Dreaming of the Jungle

Every morning Henri Rousseau used to set off for work early. He was a customs officer and spent all day standing at the gates of Paris where he lived, checking the carriages that went in and out of the city. When he got back home in the evening he was tired and worn out. He didn't really like his job very much. What do you think he would have liked to have been instead? Just have a look at the picture and you will see for yourself.

Yes, that's right, Henri wanted to be a famous painter! In the picture he is holding the tools of the trade — a paintbrush and a palette. And he has made himself very big, much bigger than everything else around him. The people strolling along the river bank look like dwarfs next to him and the ship's mast doesn't even reach up to his shoulder. Henri Rousseau wanted to be the best and most famous painter that France had ever seen. He wanted to be known all over the world.

Henri loved nature and the animals and plants. Whenever he had a day off he went for long walks and found inspiration for his paintings in the countryside. However, his favourite place was the Botanical Gardens where wonderful plants from mysterious faraway countries grew in large hothouses. He wandered through the luxuriant greenery, surrounded by warm, humid air and the strong, sweet perfume of exotic flowers in bloom. He spent many hours there, imagining that he was in a forest. Sometimes he fell asleep and dreamt it was a jungle and, in his imagination, travelled to faraway lands that he had never actually seen.

As soon as he was back home again after visiting the Botanical Gardens, Henri would sit down in front of a canvas and begin to paint wonderful pictures of the jungle expeditions he had dreamt about. Days such as these made him very happy.

Who is the strange dark figure on the banks of the wide river? The music she is playing on her flute is so beautiful that it has attracted all the animals from around about. Large, dangerous snakes are swaying tamely in time to the enchanting melody. One snake has even curled itself around the neck of the dark-skinned snake charmer. The painting has a magical feel about it. We cannot even be sure whether it is night or day—is that the sun or the moon in the sky?

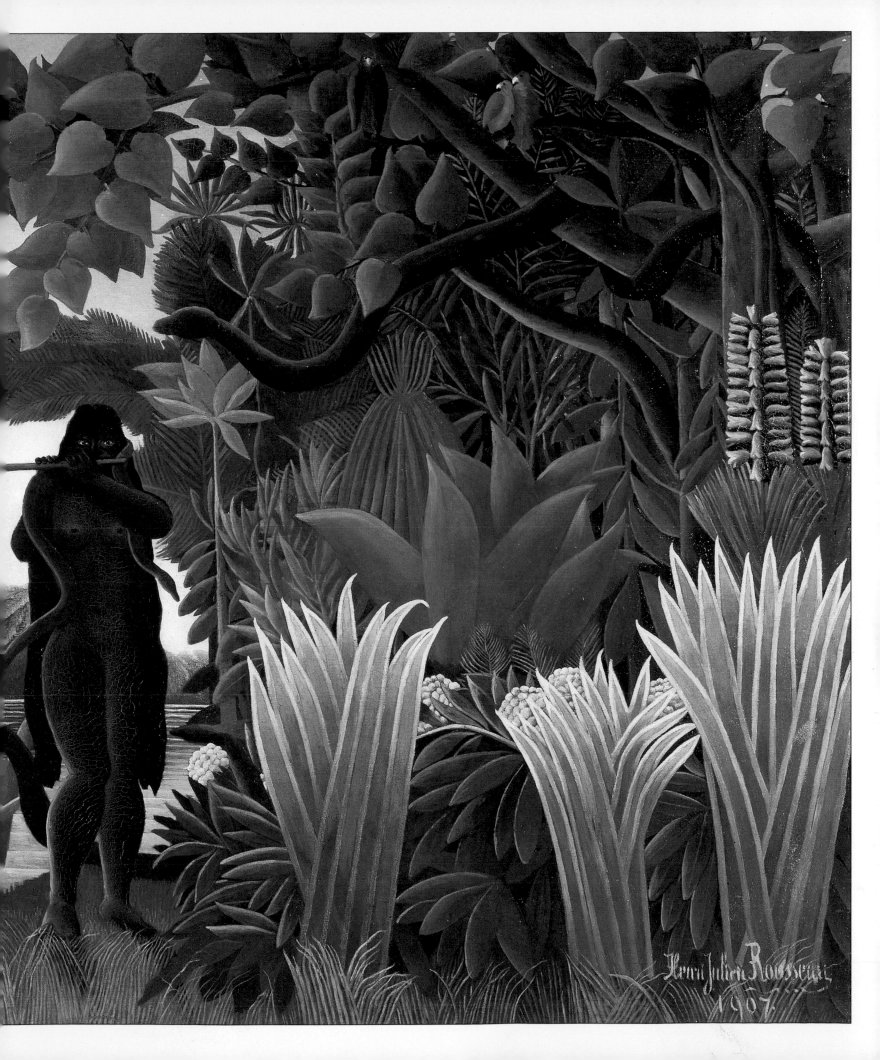

The four flamingos on the river bank are a peaceful sight. The beautiful blue sky is reflected in the water and huge water lilies are growing here. Three people on the sandbank beyond are trying to catch fish with their spears. The figures look tiny compared to the huge palms on the other side of the river.

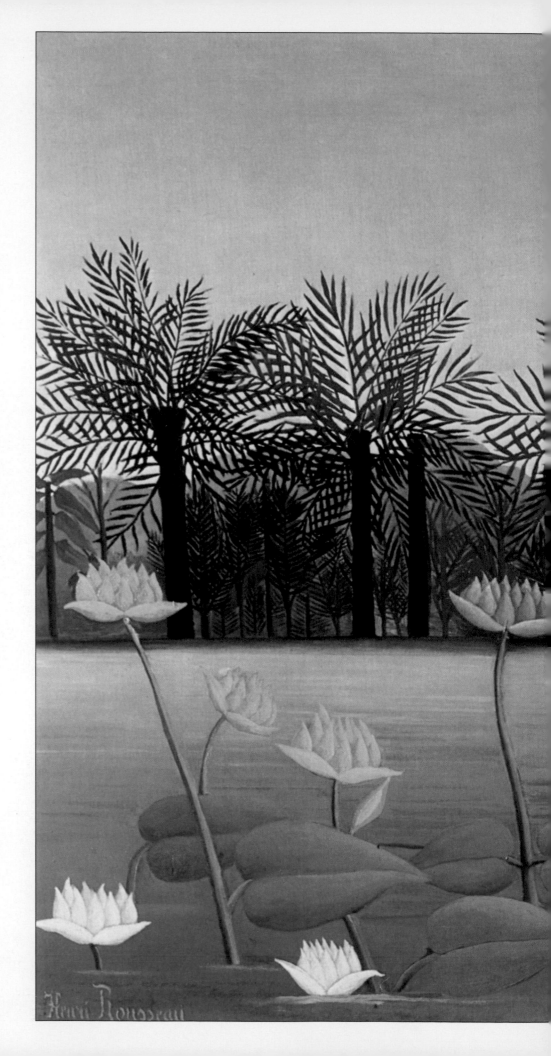

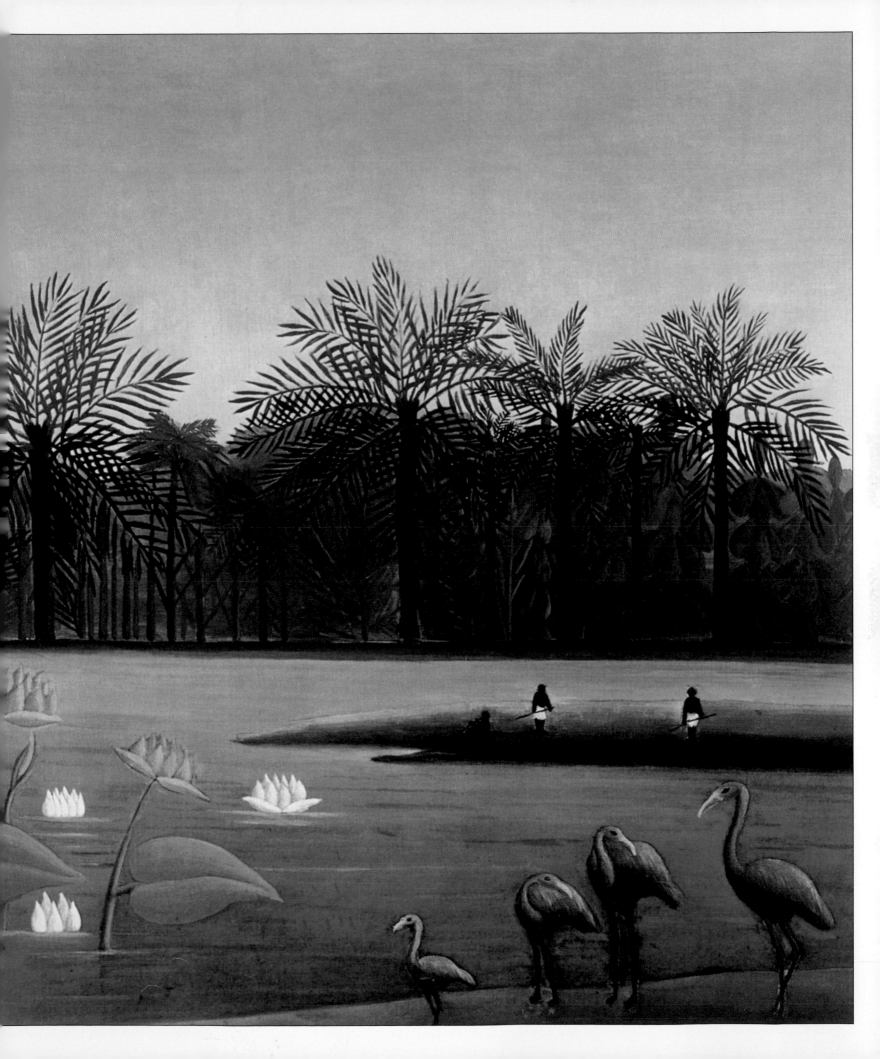

You are never alone in the thick of the jungle among the luxuriant green leaves. Where is all that rustling, chattering and snorting coming from? Lots of animals are hiding in the undergrowth. The leaves and flowers give them shelter and camouflage.

Troupes of cheeky monkeys are playing in the tree-tops and throwing oranges around …

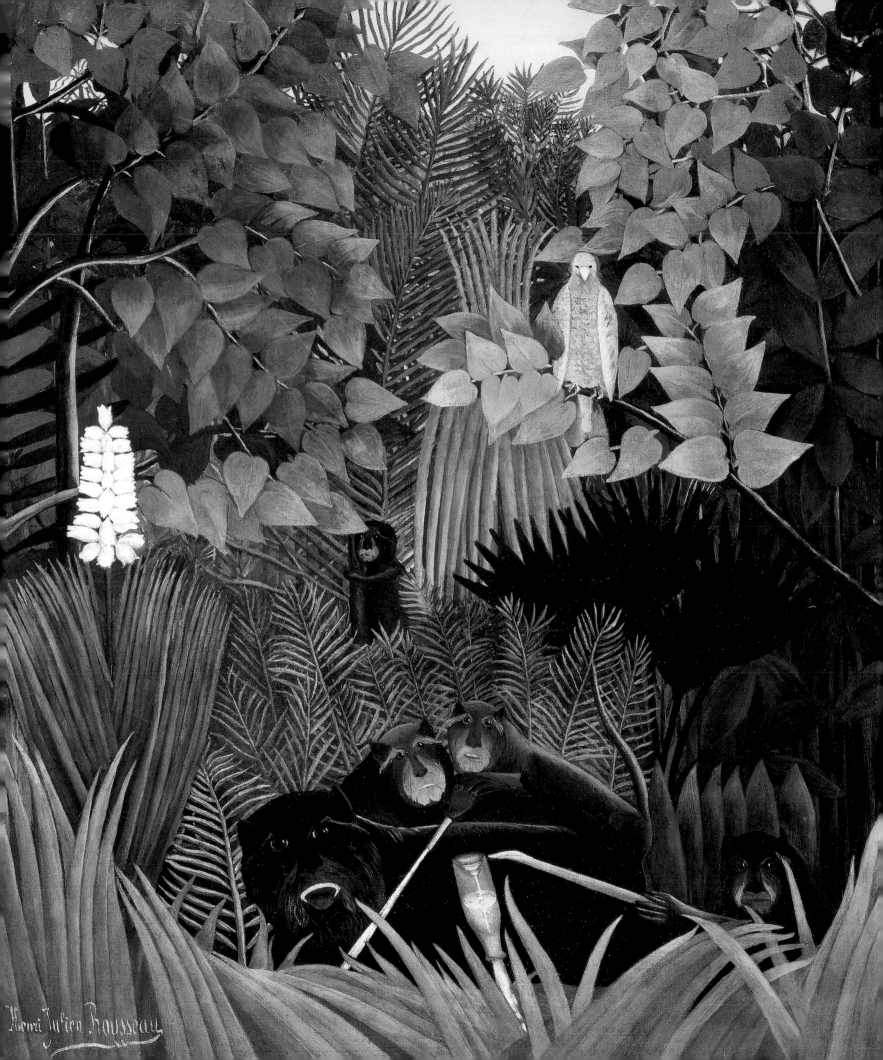

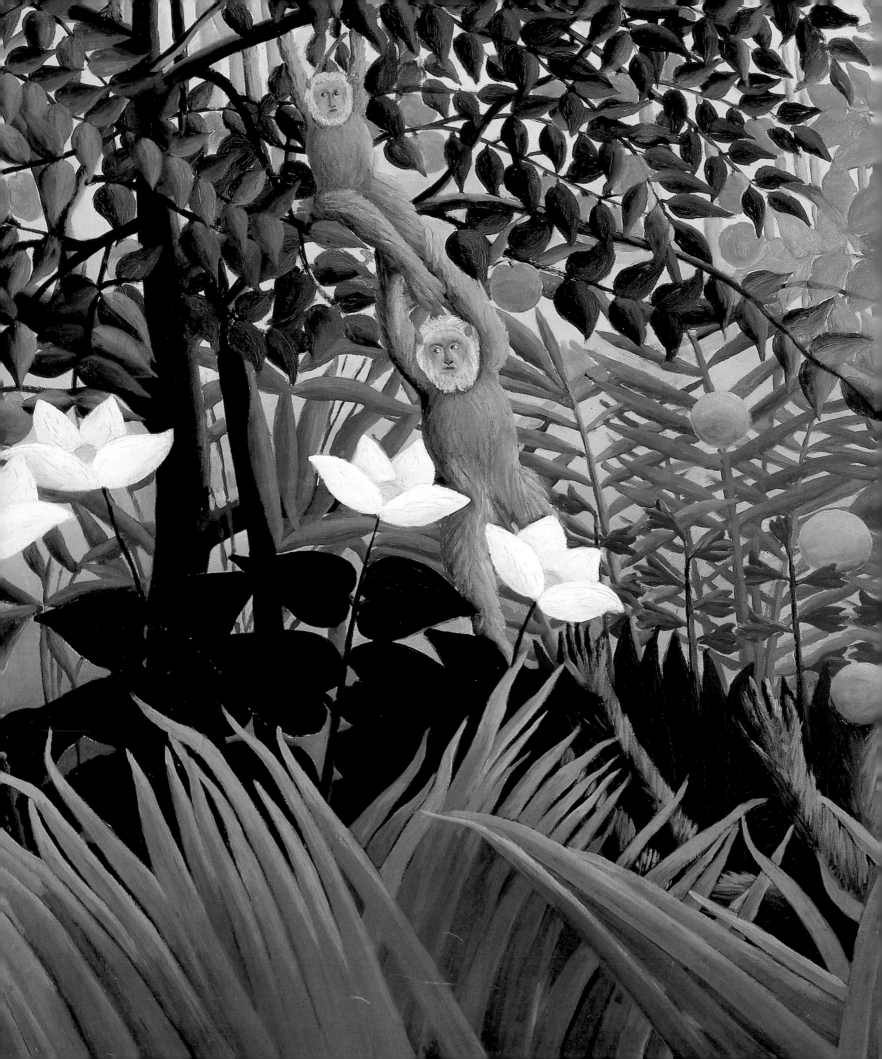

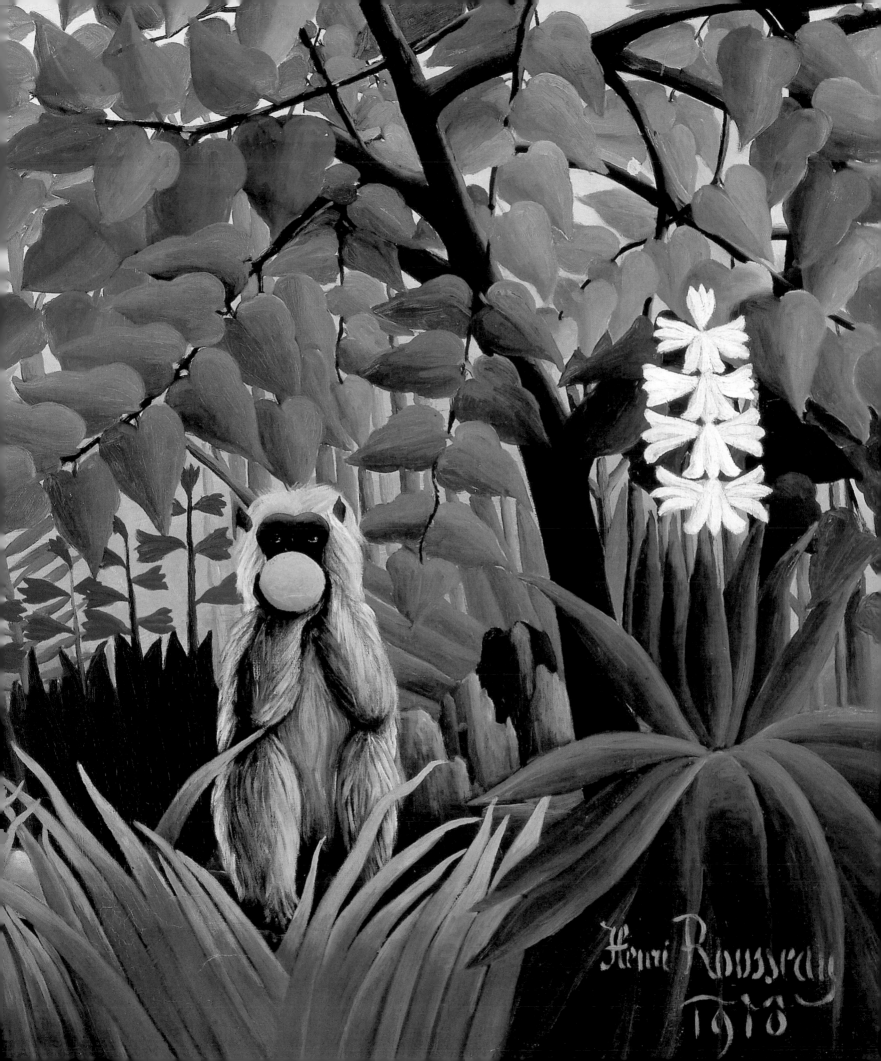

Can you see the lion, the elephant and the snake? A beautiful lady is reaching out towards a flower. Isn't she afraid of the wild animals? Once again, there is a musician playing the flute. Perhaps the music has tamed the animals.

The picture is full of puzzling questions. Why is the lovely lady naked? And how on earth did the red sofa get into the middle of the jungle?

This picture is called *The Dream*. Is the woman dreaming about the jungle or did the painter meet her in the jungle in his dreams?

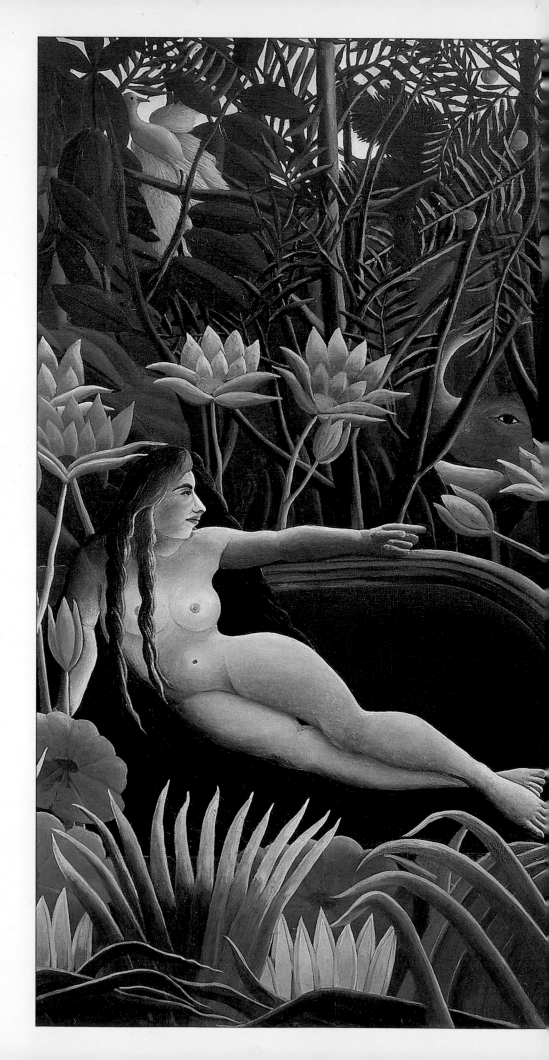

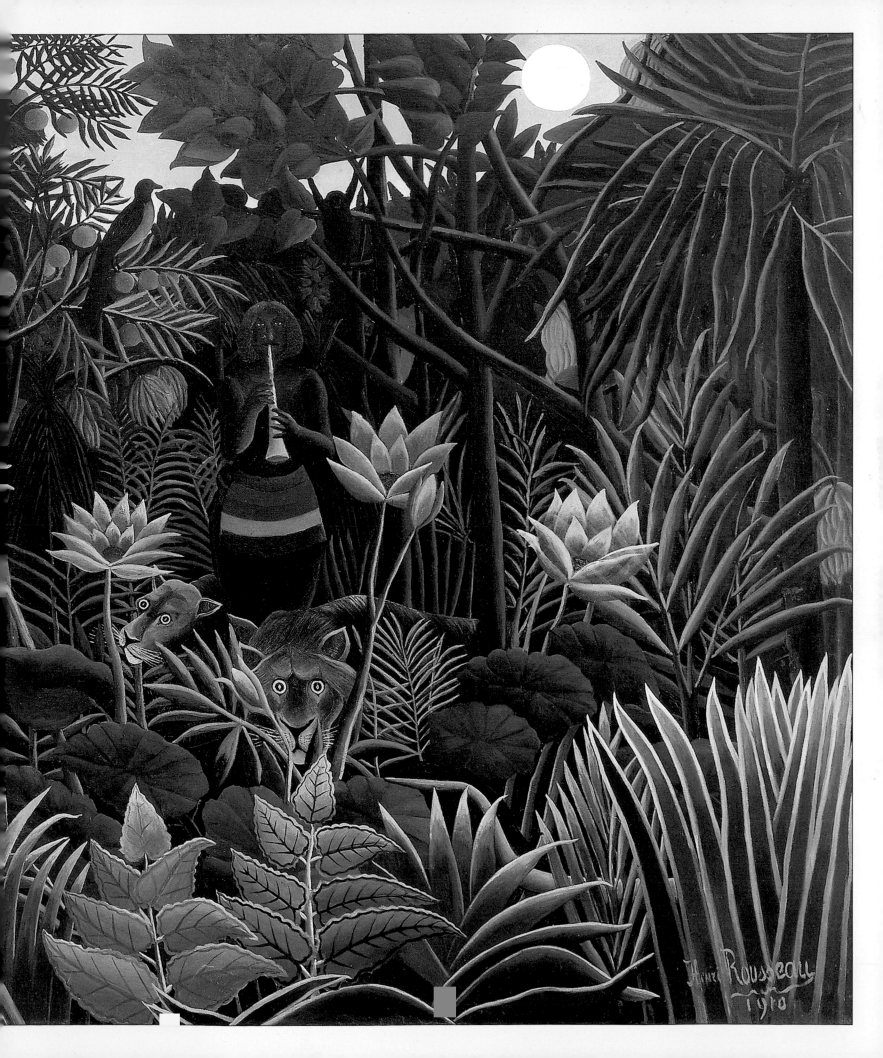

The jungle is not always a
wonderfully peaceful place.
This wild lion has just caught
another animal and wounded
it with its sharp claws and
teeth. The animal is bleeding
heavily. Another big cat is
hovering in a tree behind the
thick leaves, waiting for the
right moment to pounce. Can
you see any other animals?

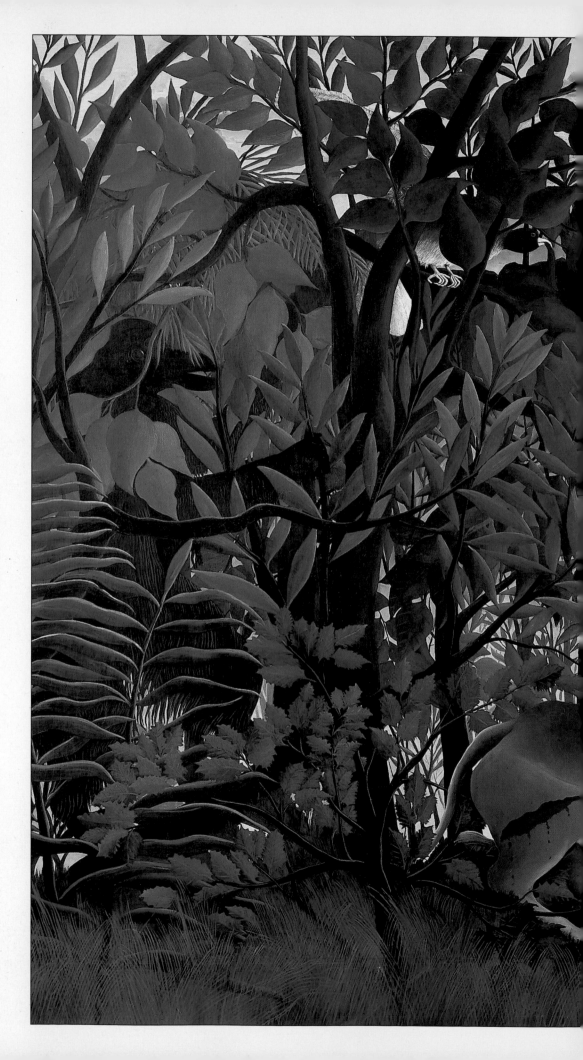

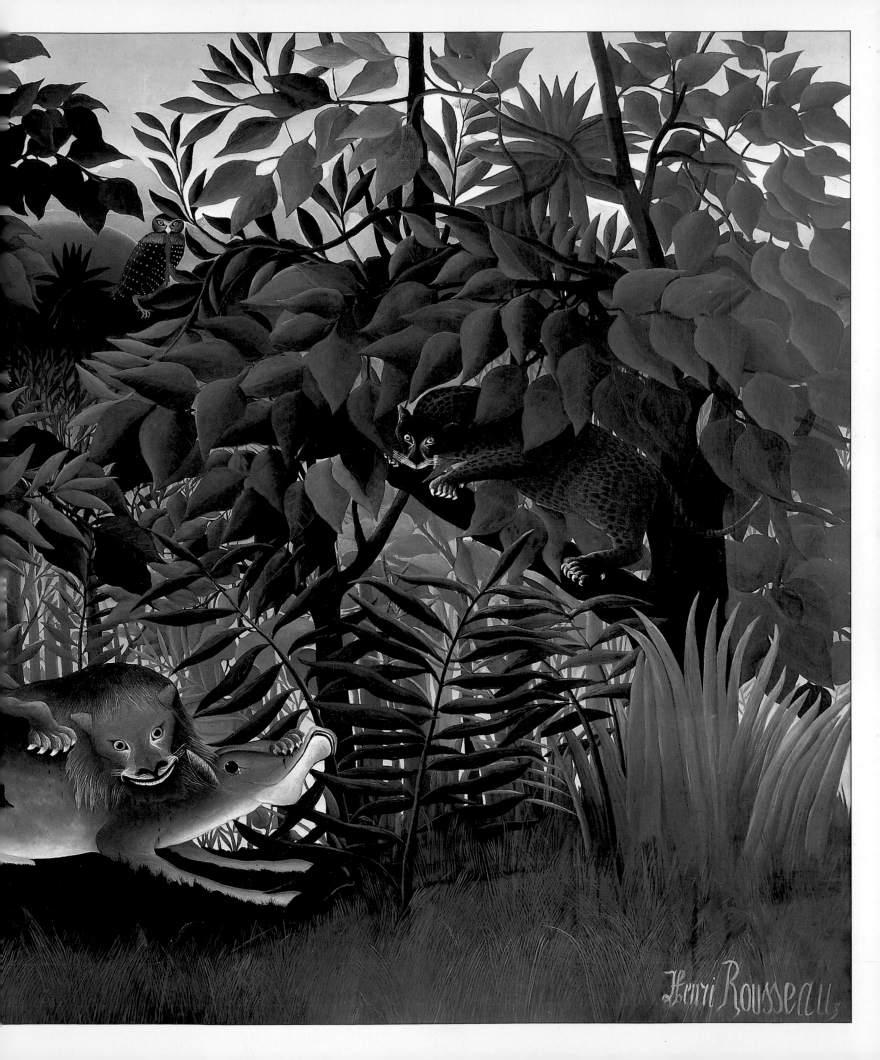

Nature also has its dangerous side. A heavy storm is breaking over the jungle. Lightning flashes across the dark sky. Rain splashes down on the leaves and a strong wind is making the trees and branches twist and turn. Even the fearless tiger doesn't like the storm!

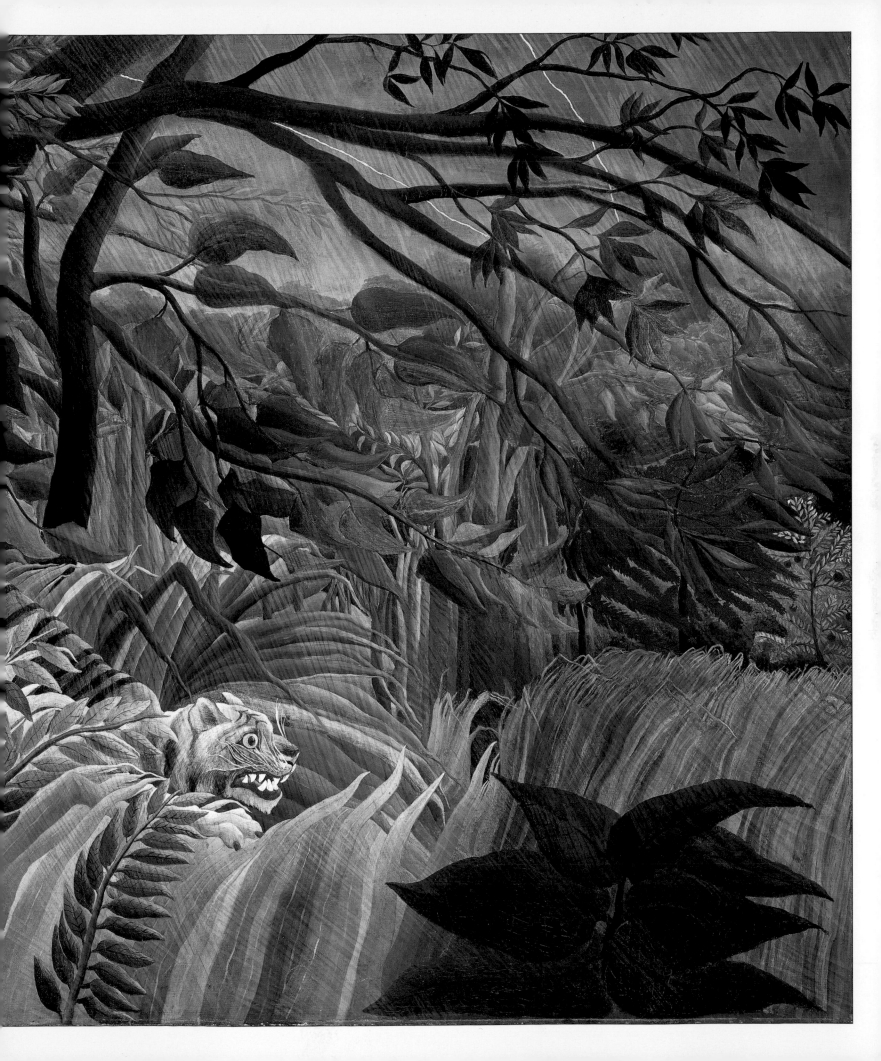

Now the sky has cleared. A couple of
people are standing next to a stream
with two animals nearby. In reality the
shy beasts would run off straight away—
but what is actually real in these paintings?
Do trees in jungles have such enormous
leaves? Are the flowers nearly as big as
people as they are in these pictures?
And does grass grow so high that it can
simply be tied together to make a hut?

In Henri Rousseau's jungle pictures, the
plants and trees tower above the people.
Everything looks tidy; narrow blades of
grass reach up to the giant, heart-shaped
leaves on a nearby tree; a dainty patchwork
of small leaves contrasts with the thick,
fleshy leaves of a bush; a patch of red is
set off by dark green, with a lighter shade
in the background. All these different
things have been carefully brought together,
like joining notes together to make a song.

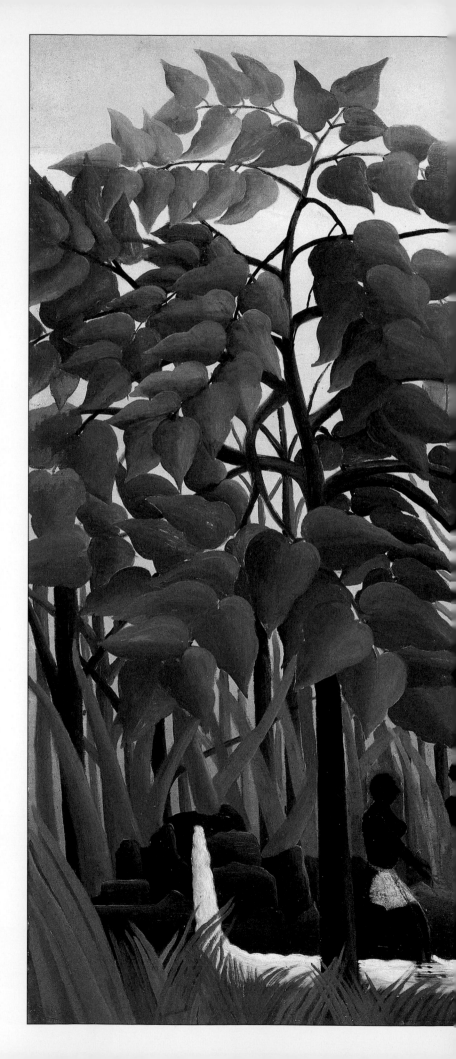

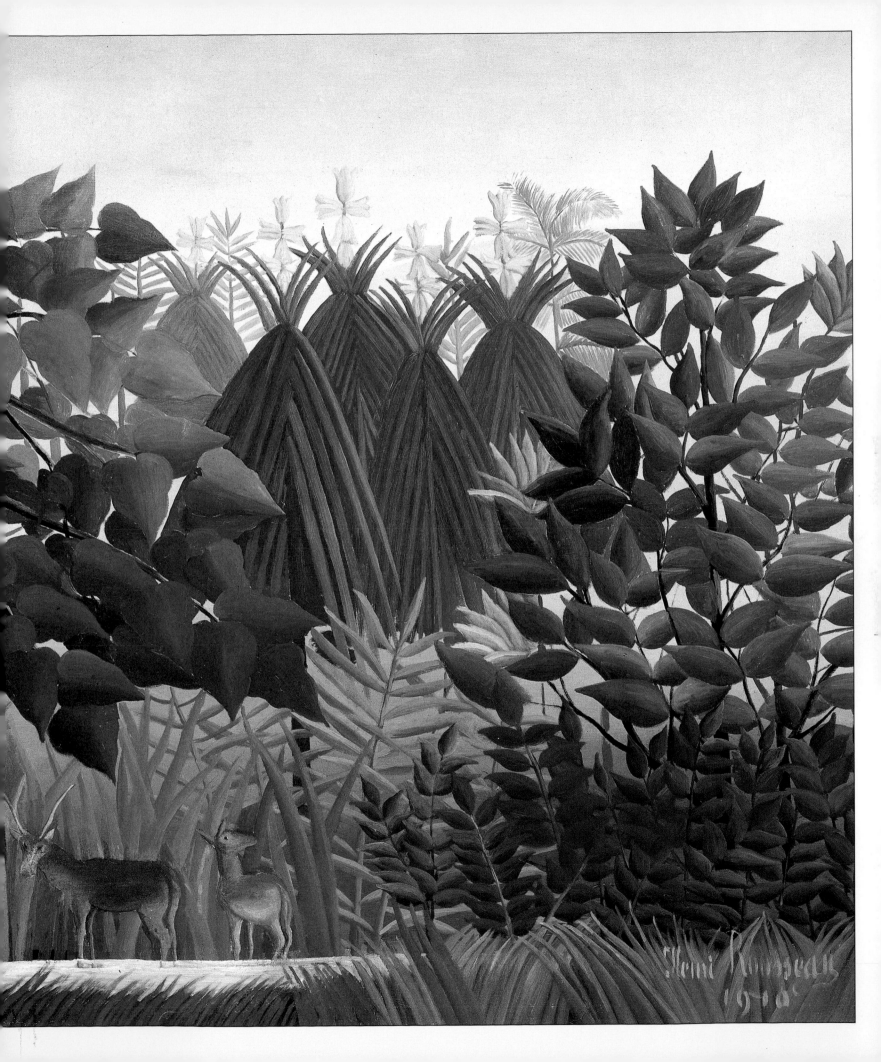

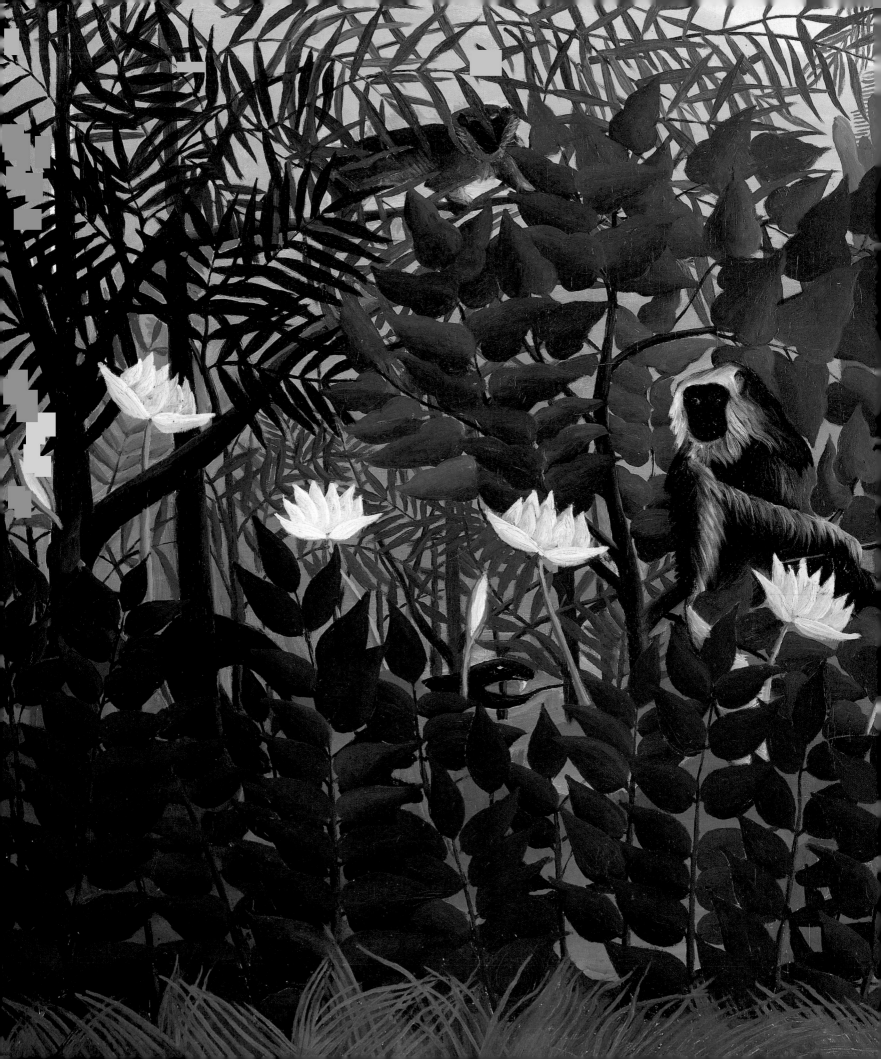

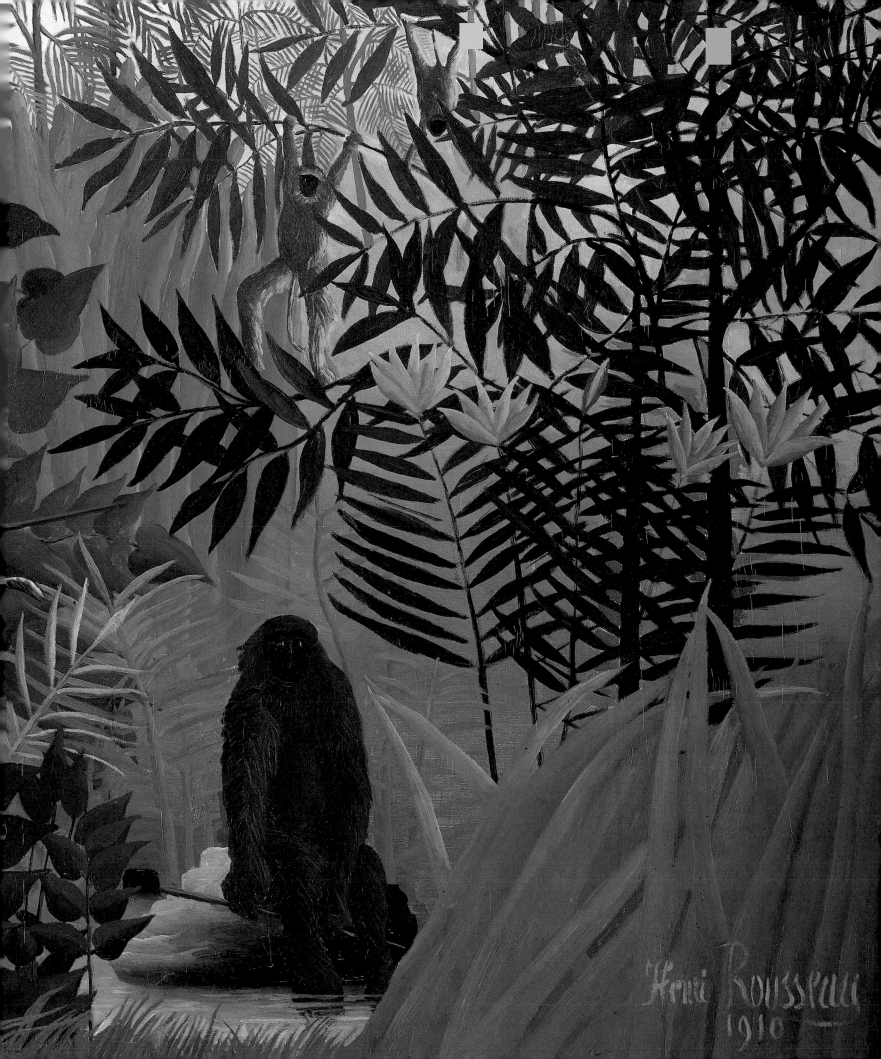

Rousseau creates a dream
world in his jungle paintings.
This mysterious lady in
colourful robes is sleeping
in another unreal landscape.
A lion has wandered up to
her but he is only sniffing
her carefully without waking
her from her dream.

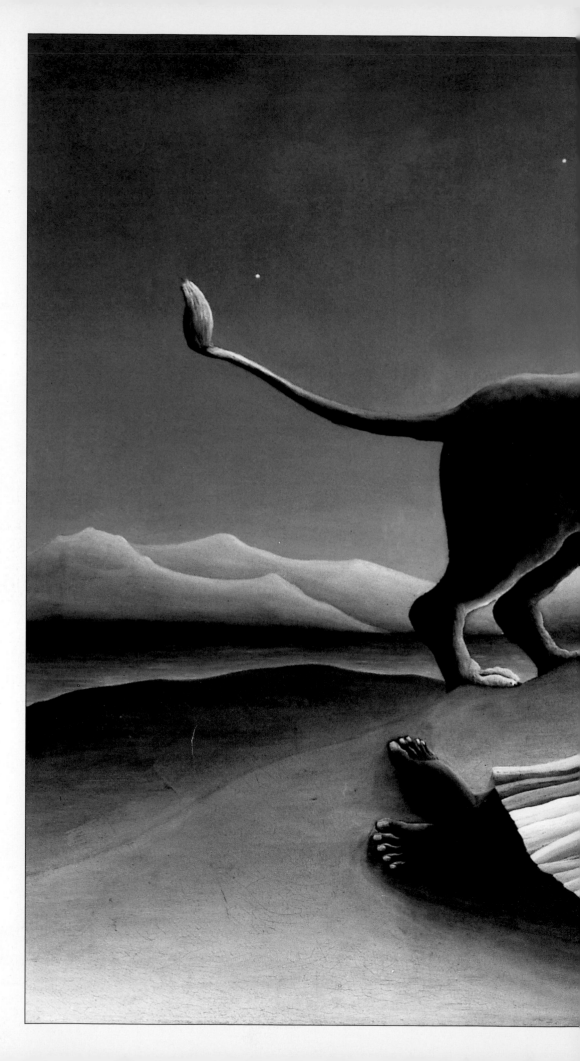

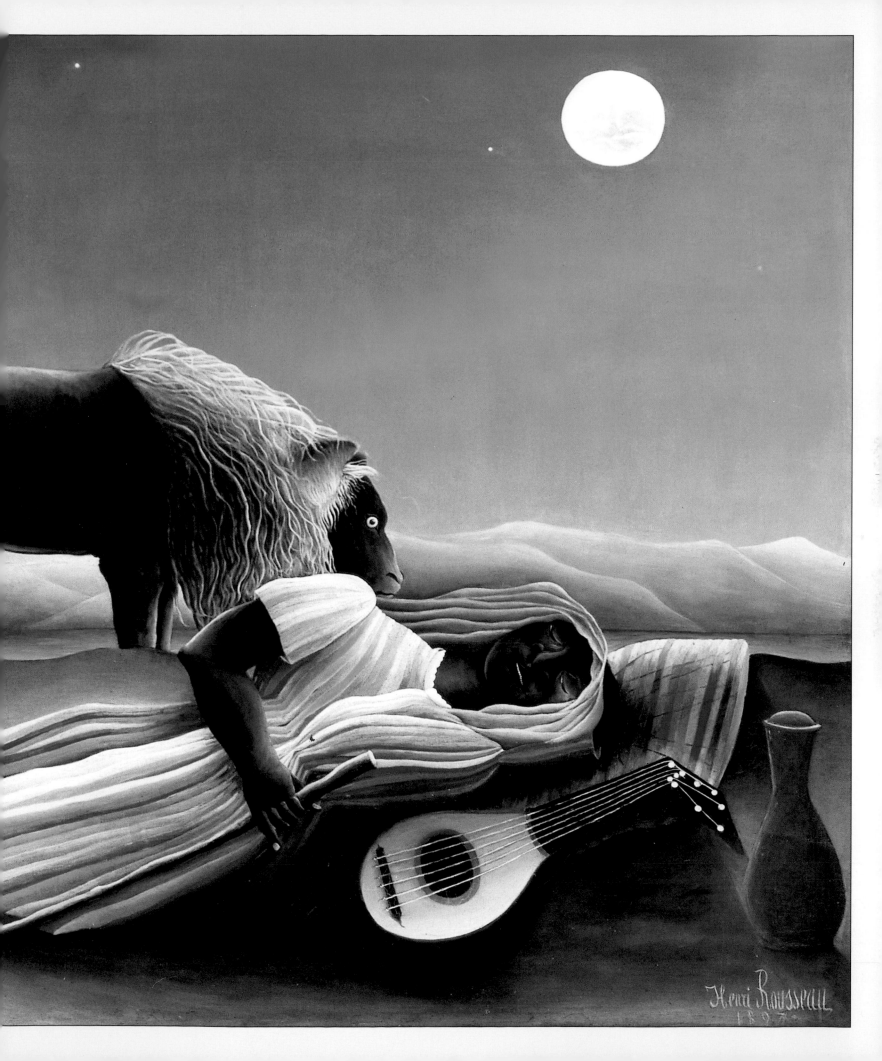

The artist's fantastic jungle paintings are made up of plants like these. The same leaves and plants appear time and again—sometimes smaller, sometimes larger and arranged in a different way. Which paintings in this book have flowers and leaves like these?

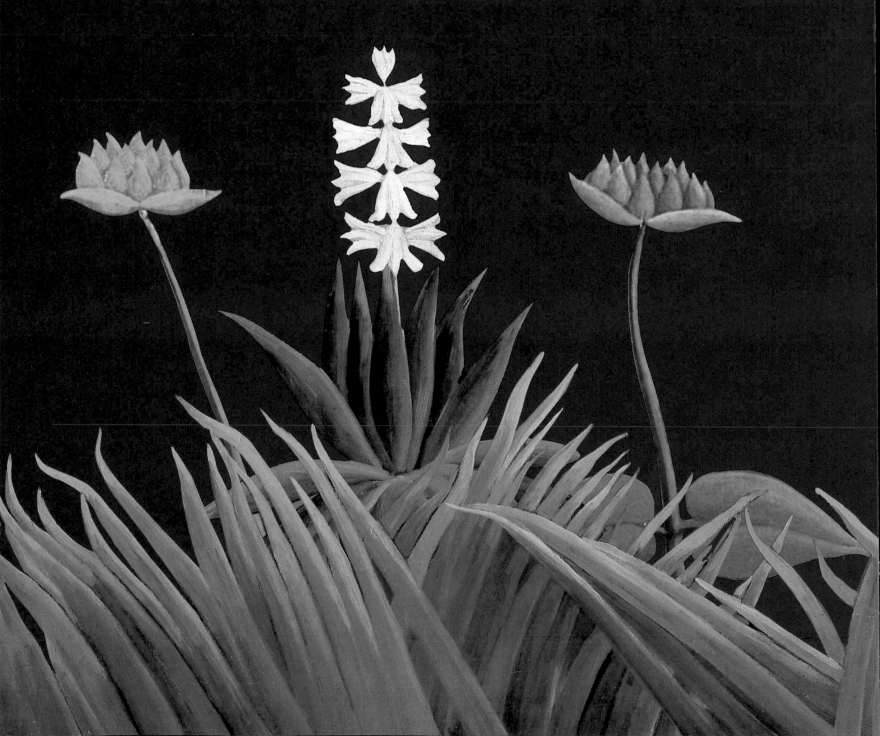

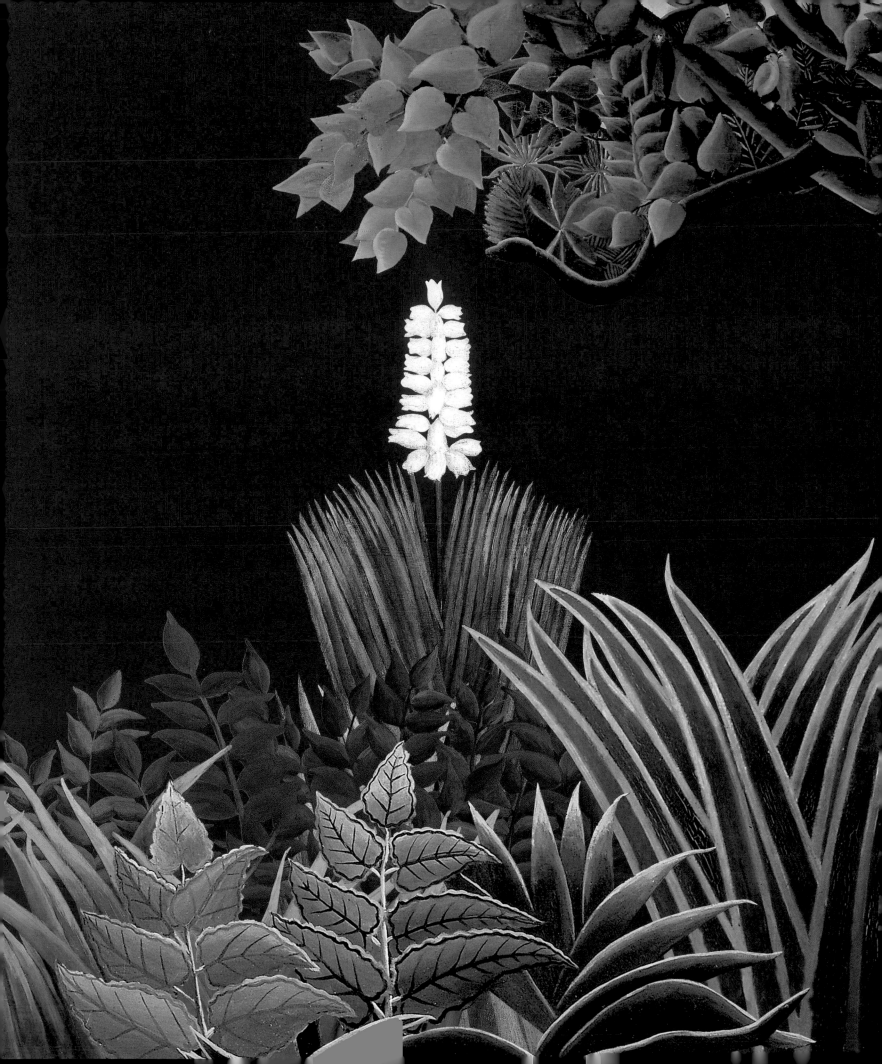

Henri Rousseau's Life

Henri-Julien-Felix Rousseau was known to everyone as 'the customs officer'. He was a bit of a mysterious man — and perhaps the strangest thing about him was his seemingly monotonous and uneventful life. The artist was born in 1844 in Laval in Brittany, France. His father was a tinsmith and his family was not very well off. Henri's childhood was unremarkable. He went to school and did his military service like all the rest. For a while he worked for a lawyer in the town of Angers where his family lived at the time.

■ The Customs Officer

When he was 25 he married Clémence Boitard. Three years later, in 1872, he moved to Paris with his wife and took a job as a toll collector. Every day for twenty years he stood at the gates of Paris and checked the goods going in an out for which duty had to be paid. He was given the nickname 'le Douanier' — the customs officer, and people still use this name for him today.

The Rousseaus lived in the lower middle-class area called Plaisance near Montparnasse. Henri evidently felt quite at home in this part of the city because, although he moved house quite often, he never left the area. Henri's well-ordered life could easily have become boring if it had not been for his passion for the arts.

This photo, taken in 1895, shows Henri Rousseau at the age of 51

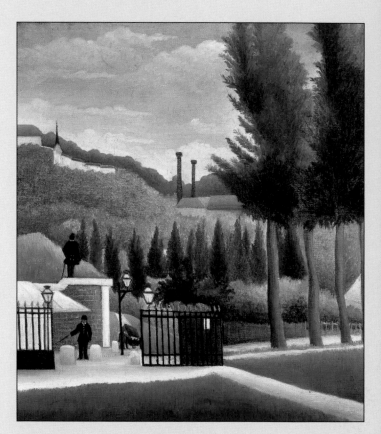

Henri Rousseau worked at the gates of Paris: one customs officer is guarding the entrance and another is keeping watch from on top of the wall. One of them could have been Rousseau.

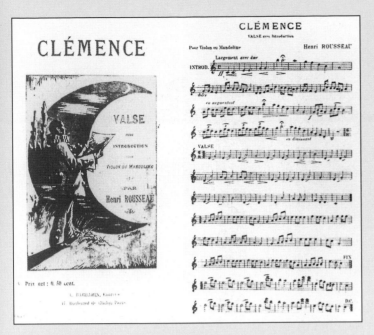

The waltz Henri Rousseau composed
was called 'Clémence' after his first wife

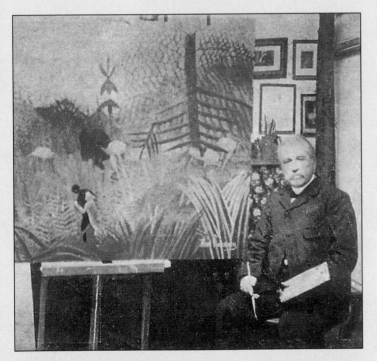

The artist in front of his painting *Jungle Landscape
with Setting Sun*, 1910

■ Art makes Life more Colourful

Henri Rousseau wrote poems and was very musical. He also
studied at the French Academy for Literature and Music in
his free time and, in 1885, earned his diploma after compos-
ing a waltz. As far as painting was concerned, Henri taught
himself and never actually studied or took lessons. He didn't
start to paint until he was 40. Rousseau had no doubts
about his own talent but was envious of the fame enjoyed
by the officially-recognised artists of the day. He once
wrote: "If my parents had known that I was such a gifted
painter, I would now be the richest most famous painter in
France today." In 1886 he showed his paintings for the first
time in the 'Salon des Indépendants' — an annual exhibition
where artists who did not belong to any official academy
could present their work to the public. From that time
onwards, Henri Rousseau exhibited his work there nearly
every year. In 1891 he showed his first jungle painting,
Surprise! — the picture of the tiger in the storm on pages
16/17.

■ Dreams of the Jungle

Rousseau's inspiration for his jungle pictures came from
his visits to Paris' Botanical Gardens where he studied the
tropical plants. "When I go into the hothouses and see the
plants from exotic countries, I feel as if I'm in a dream,"
he once told an art critic. When he was painting, Rousseau
dreamt of distant, exotic countries, although his everyday
life was dominated by his dull job as a customs officer.
In 1893, after 20 years of service, Henri Rousseau retired.
But he couldn't live from his painting.

The public did not take his work seriously and no-one wanted to buy his pictures. To earn money he gave music and art lessons to the simple working-class people in his neighbourhood and taught in a school.

In the last few years of his life, Henri Rousseau became friends with a number of famous artists and poets. Unlike the general public, they recognised his talent and appreciated his art despite (or because of) the fact that it was totally different from the popular trends found in art at that time.

However, these new contacts did nothing to change his way of life, and so people still referred to him as 'the customs officer', even after his death. Henri Rousseau died on 2 September 1910 at the age of 66.

■ 'Naïve' Painting

Rousseau was something of a loner, not only in real life but also in his art. His paintings do not fit into any particular artistic category of the times. Some people call his painting 'naïve', 'primitive' or 'folk art'. But he certainly wasn't an insignificant artist who just painted for a hobby. His works have a certain quality of their own and this turns them into something very special and unique.

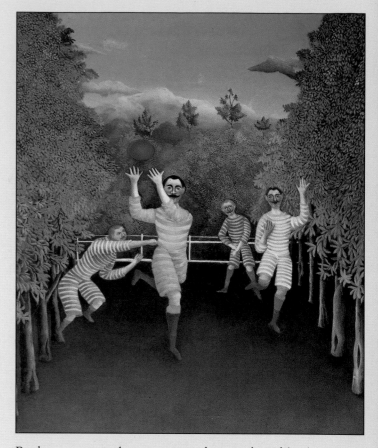

Rugby was a popular sport around 1908 when this picture was painted. This was the year when the first international rugby game was played in Paris between France and England. Here, Rousseau has painted himself on the winning side.